Retro
STYLE GRAPHICS

BY GRANT FRIEDMAN

Published by Angela Patchell Books Ltd
www.angelapatchellbooks.com

Registered address
21B Marlborough Rd.
Richmond, London

Contact sales and editorial
sales@angelapatchellbooks.com
angie@angelapatchellbooks.com

ISBN: 978-1-906245-16-0

Book designed and written by Grant Friedman
www.colorburned.com

Book concept by Angela Patchell

Retro

STYLE GRAPHICS

BY GRANT FRIEDMAN

Table of Contents

INTRODUCTION

The term retro is often used to describe past trends in fashion, design, or architecture. If you have ever been to a movie, gone shopping or walked the streets of a town; large or small; odds are, you are familiar with retro design. Retro design is everywhere. You can see it in the cars we drive, the homes we live in, and the shows we watch on TV It is because of this daily inoculation that most of us have a fairly good grasp of what items are considered retro and what items are not.

If you have ever compared designs from earlier eras, you may have noticed how each era seems to have their own unique look and feel. Designs from the 1970s for instance have a different look and feel from that of the 1980s. This is because each decade tends to utilize specific design elements such as colors, shapes, patterns, and fonts in their composition. The combination of these elements make designs from these time periods unique from that of any other period.

Retro Style Graphics is a collection of design elements inspired by the 1960s, 1970s, and 1980s. The purpose of this book is to provide the resources needed to reproduce the look of graphics created during these time periods. Inside this book you will find a free CD that includes retro inspired color palettes, professional quality vector graphics, vector patterns, retro styled Illustrator and Photoshop brushes, and high resolution textures.

This book also includes a reference guide to some of the best retro style fonts and a retro design gallery for inspiration. But because reproducing graphics in the retro style is more than just how you organize shapes, colors, patterns and fonts on a page, this book also includes an amazing list of retro design websites and tutorials to help put these design resources to use.

Retro Style Graphics truly is a "must buy" for any professional designer who wants to produce high quality graphics in the retro style.

Inspiration

"Retro design can remind us of earlier, simpler, and happier times."

As a designer, I'm a creative person. I am always looking for ways to make my newest design better than the last. I think this is a fairly common trait among all designers; we are always looking for ways to push the envelope. As a design blogger I spend a lot of my time researching design trends. Following design trends and reporting them on my blog is one of the most fascinating aspects of my job. I suppose that in addition to being a designer, I am also part journalist. I just love asking designers how their style has evolved over time. That is how I became fascinated with retro design.

Understanding the history of design is a key element to predicting its future. For instance, if you ask enough contemporary designers how their style was influenced, eventually you will find yourself talking about a designer that worked several decades ago. That is how I became interested in retro design, the more I learned about earlier designers, the more I wanted to learn how they created the designs that they did.

Researching material for this book was easier than I thought it would be. It didn't take me long to figure out that the inspiration for this book could be found everywhere. All I had to do was walk the streets of my hometown to find it. City streets are littered with retro inspiration. It is evident in everything from the architecture of the buildings, to the signs that dress them; from the automobiles parked on the streets, to the clothing of the people who own them.

I spent several months observing my surroundings, documenting all sorts of retro-inspired designs. When I was done I found that there were several elements that made up the retro style. I then began documenting these elements so that I could reproduce them digitally for you to use in your designs.

The resources found in this book were inspired by what I saw around me; the city that I live in, the stores that I shop in and even what I saw on TV and the Internet. What I found was that retro design is something that everyone can relate to. It's nostalgic; it reminds us of earlier, simpler times and in many cases can induce laughter and thoughts of happier times.

It is my hope that by sharing what I've learned about retro design I can inspire you as much as it has inspired me.

On the CD

Open the CD attached to the inside cover of this book and browse to the "Seamless Patterns" directory. Within that folder you will find a collection of retro-style seamless patterns in several formats including Adobe Illustrator, Adobe Photoshop, as well as standard JPEG files.

PATTERNS

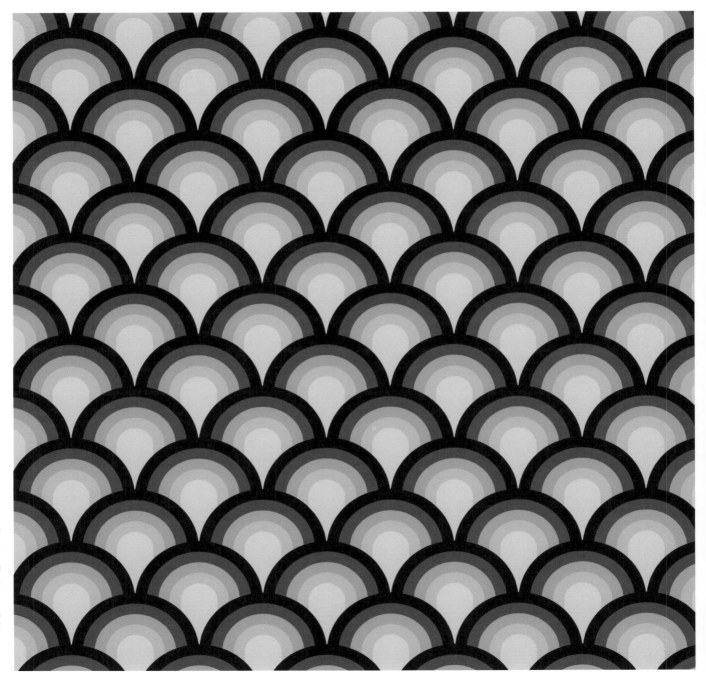

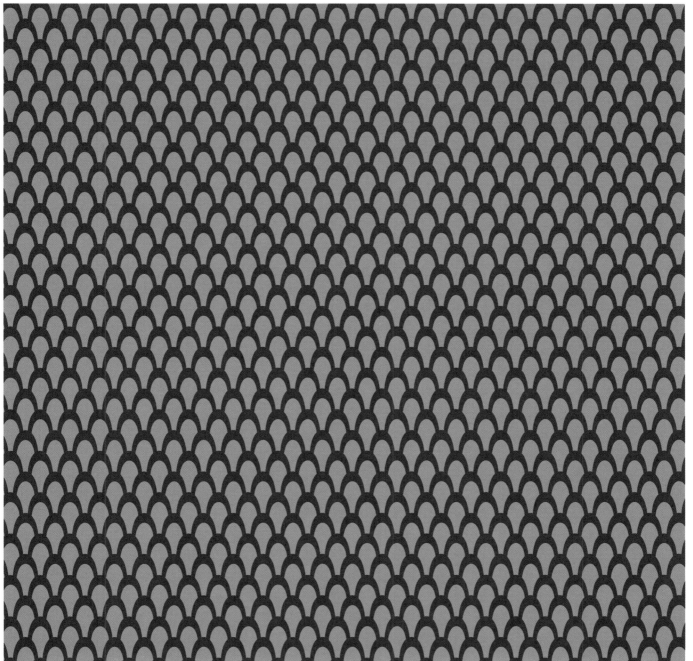

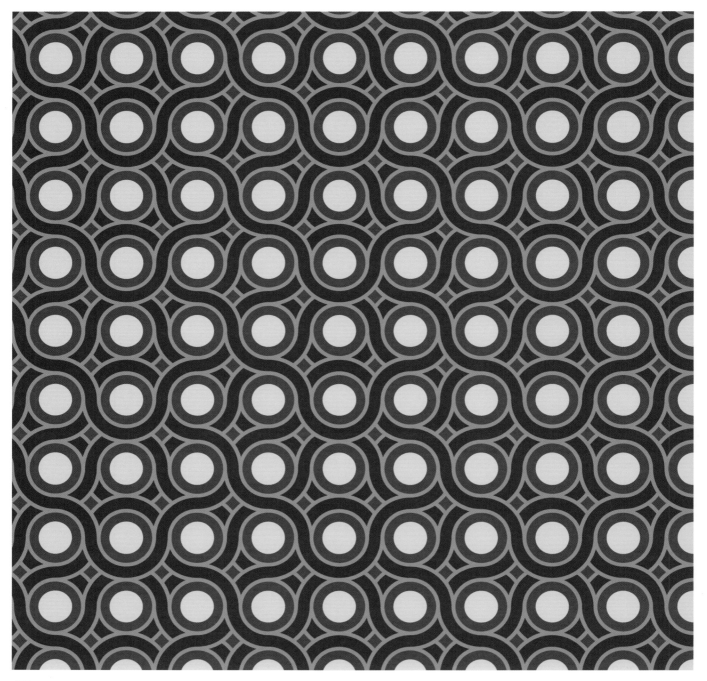

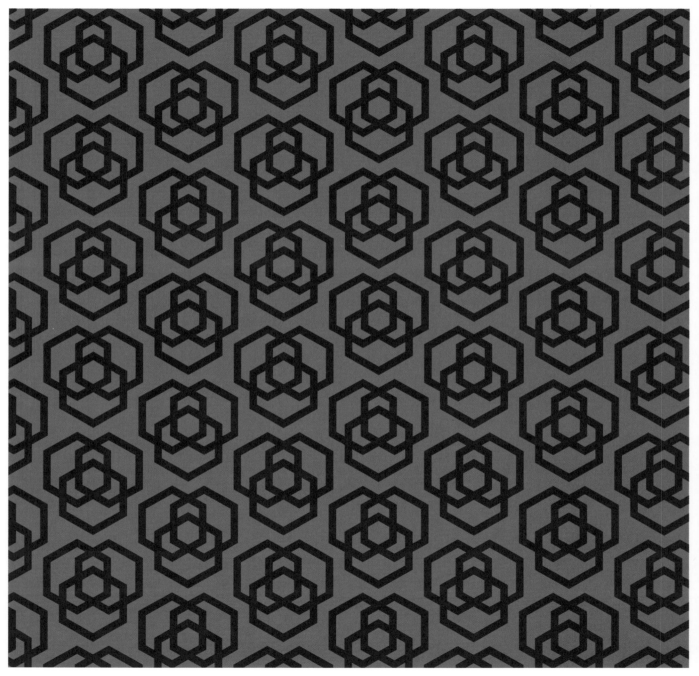

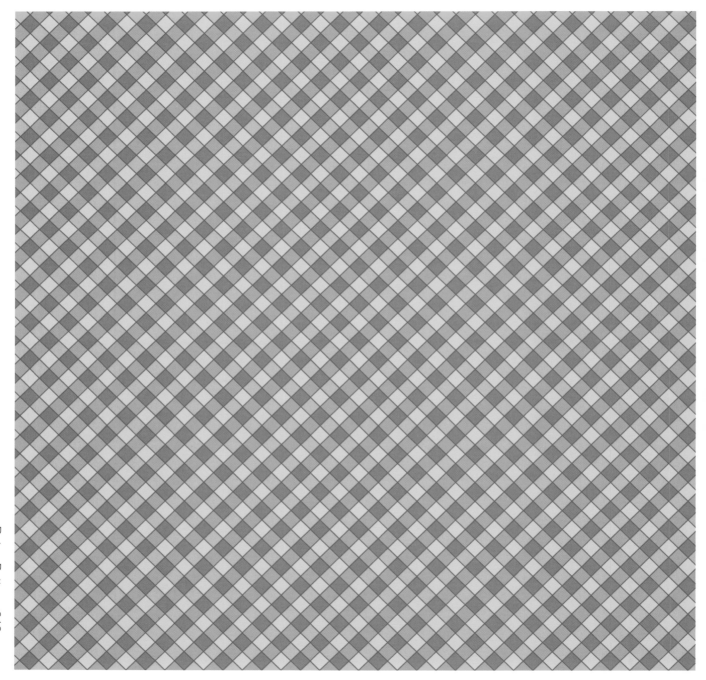

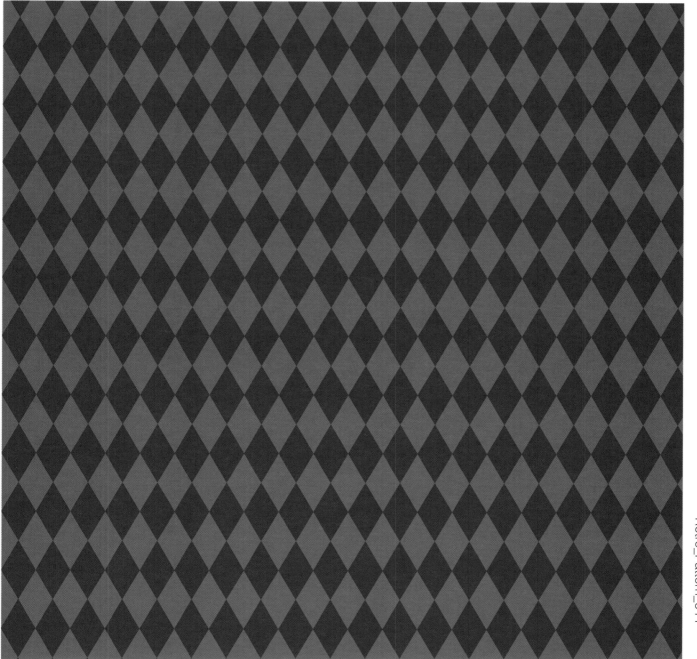

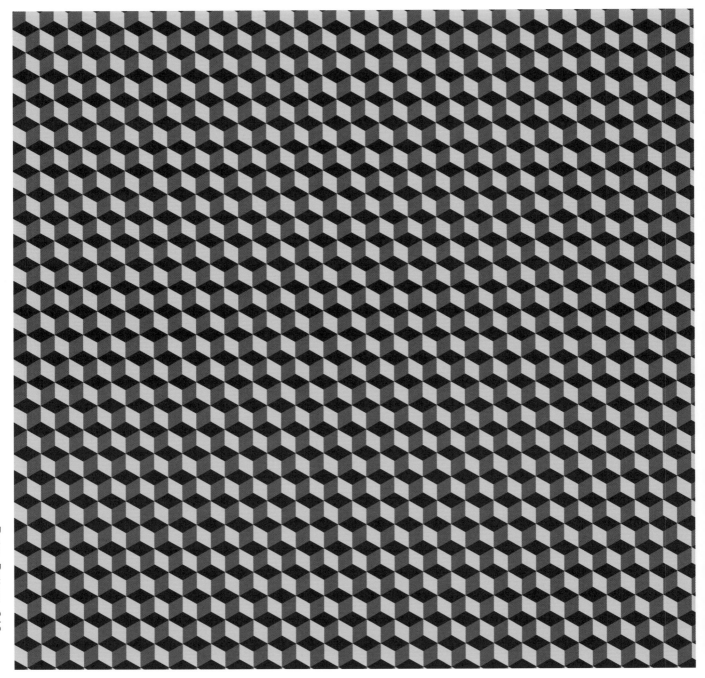

Retro_Pattern_021

42

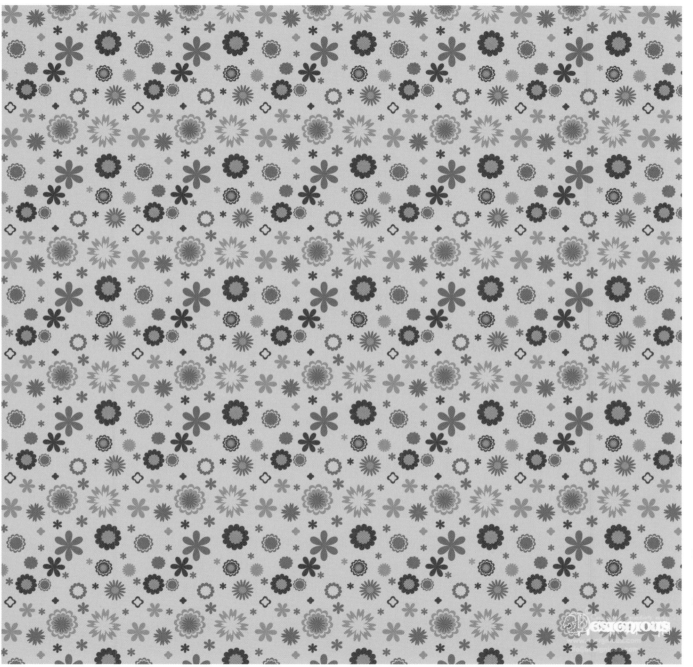

Retro Typography

Retro typography is one of the most important aspects of retro-style design. While most people aren't consciously aware of the type that is used in your design, the type that you use will affect them on a subconscious level. This section is a collection of some of the best retro-style fonts available.

FONT GUIDE

Aeolian
by Harold Lohner

AEOLIAN

Aeolian Bold
by Harold Lohner

AEOLIAN BOLD

Aeolian Demi Bold
by Harold Lohner

AEOLIAN DEMI BOLD

Air Conditioner
by Font Diner

Air Conditioner

ALS Motor-Inn
by Font Diner

ALS Motor-Inn

Anastasia
by Font Diner

Anastasia

Artistamp Medium
by Harold Lohner

ARTISTAMP MEDIUM

Artistamp Medium Jumbled
by Harold Lohner

ARTISTAMP MEDIUM JUMBLED

Artistamp Wet
by Harold Lohner

ARTISTAMP WET

Artistamp Wet Jumbled
by Harold Lohner

ARTISTAMP WET JUMBLED

Automatic
by Font Diner

AUTOMATIC

Bahama Slim
by Font Diner

Bahama Slim

Bank Gothic AS Condensed
by Alphabet Soup

Bank Gothic AS Condensed

Bank Gothic AS Condensed SC
by Alphabet Soup

BANK GOTHIC AS CONDENSED SC

Bank Gothic AS Regular
by Alphabet Soup

Bank Gothic AS Regular

Black Widow
by Font Diner

Black Widow

Blakely Black
by Mark Simonson

BLAKELY BLACK

Blakely Bold
by Mark Simonson

BLAKELY BOLD

Blakely Light
by Mark Simonson

BLAKELY LIGHT

Bubble Man
by Font Diner

Chicken King
by Font Diner

CHICKEN KING

Chowderhead
by Font Diner

Chowderhead

Cocktail Script
by Font Diner

Cocktail Script

Cocktail Shaker
by Sideshow

Cocktail Shaker

Coffee Service
by Sideshow

Coffee Service

Crazy Harold Condensed Flare
by Harold Lohner

Crazy Harold Condensed Flare

Crazy Harold Flare
by Harold Lohner

Crazy Harold Flare

Creaky Frank
by Font Diner

CREAKY FRANK

Dairyland
by Font Diner

DAIRYLAND

Decaying Kuntry
by Font Diner

Decaying Kuntry

Doggie Bag Script
by Font Diner

FONTDINER.COM
COMMERCIAL

Doggie Bag Script

Doinkbats
by Sideshow

FONTBROS.COM
COMMERCIAL

Doinky
by Sideshow

FONTBROS.COM
COMMERCIAL

Doinky

Doinky Inline
by Sideshow

FONTBROS.COM
COMMERCIAL

Doinky Inline

Dry Cleaners
by Font Diner

FONTDINER.COM
COMMERCIAL

DRY CLEANERS

Famous Label
by Harold Lohner

Fat Sam
by Font Diner

Featured Item
by Font Diner

FEATURED ITEM

Filmotype Ginger
by Mark Simonson

Filmotype Ginger

Filmotype Glenlake Regular
by Mark Simonson

Filmotype Glenlake Regular

Font-On-A-Grain
by Font Diner

FONTDINER.COM
FREE

FONT-ON-A-GRAIN

Font-On-A-Stick
by Font Diner

FONTDINER.COM
FREE

Font-On-A-Stick

Graceful Ghost
by Harold Lohner

FONTBROS.COM
COMMERCIAL

GRACEFUL GHOST

Guest Check
by Font Diner

FONTDINER.COM
COMMERCIAL

GUEST CHECK

Hamburger Menu
by Font Diner

FONTDINER.COM
COMMERCIAL

HAMBURGER MENU

Kentuckyfried
by Font Diner

Kentuckyfried

Kiddie Cocktails
by Font Diner

KIDDIE COCKTAILS

Kinescope
by Mark Simonson

Kinescope

Kitchenette
by Font Diner

Kitchenette

Lakeside
by Mark Simonson

Lakeside

Lamplighter Script
by Font Diner

Lamplighter Script

Lamplighter Script Marquee
by Font Diner

Lamplighter Script Marquee

Las Vegas to Rome
by Font Diner

LAS VEGAS TO ROME

Leftovers
by Font Diner

Leftovers

Leisure Script
by Font Diner

Leisure Script

Marker Monkey
by Font Diner

MaRKeR MONKey

Maverick
by Font Diner

MAVERICK

Metroscript
by Alphabet Soup

Metroscript

Milwaukee
by Font Diner

MILWAUKEE

Milwaukee Neon Neon
by Font Diner

MILWAUKEE NEON NEON

Motel King
by Font Diner

MOTEL KING

Motor Oil
by Font Diner

MOTOR OIL

Motorcar Atlas
by Font Diner

Motorcar Atlas

Musicals
by Font Diner

MUSICALS

New York to Las Vegas
by Font Diner

New York to Las Vegas

Orion MD
by Alphabet Soup

FONTBROS.COM
COMMERCIAL

Orion MD

Permanent Waves
by Font Diner

FONTDINER.COM
COMMERCIAL

Permanent Waves

Permanent Waves Expanded
by Font Diner

FONTDINER.COM
COMMERCIAL

Permanent Waves Expanded

Pick Ax
by Font Diner

FONTDINER.COM
FREE

Pick Ax

Pink Flamingo
by Font Diner

FONTDINER.COM
COMMERCIAL

Pink Flamingo

Power Station Wedge Wide High
by Alphabet Soup

POWER STATION WEDGE WIDE HIGH

Power Station Wedge Wide Low
by Alphabet Soup

POWER STATION WEDGE WIDE LOW

Queen Rosie
by Font Diner

QUEEN ROSIE

Rebecca
by Harold Lohner

Rebecca

Refreshment Stand
by Font Diner

Refreshment Stand

Refrigerator Deluxe

Refrigerator Deluxe Bold

Refrigerator Deluxe Heavy

Refrigerator Deluxe Light

REGULATOR

Rickles
by Font Diner

Rickles

Rocket Script
by Font Diner

Rocket Script

Rojo Frijoles
by Font Diner

Rojo frijoles

Roselyn
by Harold Lohner

Roselyn

Savage Hipsters
by Sideshow

Savage Hipsters

Starlight Hotel
by Font Diner

Starlight Hotel

Stencil Gothic
by Font Diner

Stencil Gothic

Stiletto
by Font Diner

stiletto

Stovetop
by Font Diner

Stovetop

Sweet Rosie
by Font Diner

SWEET ROSIE

Swinger
by Font Diner

FONTDINER.COM
COMMERCIAL

SWINGER

Taylors
by Font Diner

FONTDINER.COM
COMMERCIAL

TAYLORS

That's Super
by Font Diner

FONTDINER.COM
FREE

THAT'S SUPER

Turnpike
by Font Diner

FONTDINER.COM
FREE

TURNPIKE

Varga
by Alan Meeks

LINOTYPE.COM
COMMERCIAL

Varga

Vegas Caravan
by Font Diner

VEGAS CARAVAN

Volcano King
by Font Diner

VOLCANO KING

WARNING
by Font Diner

WARNING

Witless
by Font Diner

WITLESS

Xerker
by Font Diner

XERKER

On the CD

Open the CD attached to the inside cover of this book and browse to the "Color Palettes" directory. Within that folder you will find a variety of retro-inspired ASE (Adobe Swatch Exchange) files that can be used in several of your favorite Adobe products.

COLOR PALETTES

PALETTE 001

RGB 202 198 212	RGB 181 43 37	RGB 252 252 248	RGB 240 227 109	RGB 107 160 119
CMYK 20 19 8 0	CMYK 20 96 100 11	CMYK 1 0 2 0	CMYK 7 4 71 0	CMYK 62 20 65 2
HEX CAC6D4	HEX B52B25	HEX FCFCF8	HEX F0E36D	HEX 6BA077

PALETTE 002

RGB 205 144 113	RGB 237 226 194	RGB 214 211 184	RGB 198 200 178	RGB 176 184 171
CMYK 18 47 57 1	CMYK 7 8 25 0	CMYK 16 12 29 0	CMYK 23 15 31 0	CMYK 33 20 32 0
HEX CD9071	HEX EDE2C2	HEX D6D3B8	HEX C6C8B2	HEX B0B8AB

PALETTE 003

RGB 82 51 22	RGB 255 201 7	RGB 243 116 33	RGB 239 70 35	RGB 69 41 32
CMYK 45 69 92 56	CMYK 0 21 100 0	CMYK 0 68 100 0	CMYK 0 88 100 0	CMYK 49 71 74 64
HEX 523316	HEX FFC907	HEX F37421	HEX EF4623	HEX 452920

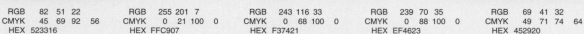

PALETTE 004

RGB 211 147 147
CMYK 16 48 33 0
HEX D39393

RGB 174 172 172
CMYK 33 28 28 0
HEX AEACAC

RGB 100 101 101
CMYK 60 52 51 21
HEX 646565

RGB 53 53 53
CMYK 69 63 62 56
HEX 353535

RGB 0 0 0
CMYK 0 0 0 100
HEX 000000

PALETTE 005

RGB 17 22 44
CMYK 91 83 51 66
HEX 11162C

RGB 253 249 209
CMYK 1 0 22 0
HEX FDF9D1

RGB 42 157 172
CMYK 76 20 31 0
HEX 2A9DAC

RGB 24 83 89
CMYK 89 52 54 31
HEX 185359

RGB 16 22 44
CMYK 90 82 51 67
HEX 10162C

PALETTE 006

RGB 188 164 70
CMYK 28 30 87 2
HEX BCA446

RGB 183 148 69
CMYK 28 38 86 4
HEX B79445

RGB 178 129 67
CMYK 27 48 84 7
HEX B28143

RGB 203 217 78
CMYK 24 1 85 0
HEX CBD94E

RGB 151 26 56
CMYK 27 100 73 23
HEX 971A38

PALETTE 007

RGB 111 132 83	RGB 193 160 67	RGB 172 68 36	RGB 71 54 21	RGB 30 22 11
CMYK 59 33 78 13	CMYK 25 34 88 2	CMYK 23 84 100 15	CMYK 53 62 94 58	CMYK 64 66 74 82
HEX 6F8453	HEX C1A043	HEX AC4424	HEX 473615	HEX 1E160B

PALETTE 008

RGB 164 191 59	RGB 224 200 34	RGB 242 98 34	RGB 213 32 39	RGB 142 31 28
CMYK 41 9 99 0	CMYK 15 16 100 0	CMYK 0 76 100 0	CMYK 10 100 100 2	CMYK 27 98 100 29
HEX A4BF3B	HEX E0C822	HEX F26222	HEX D52027	HEX 8E1F1C

PALETTE 009

RGB 240 192 96	RGB 239 168 31	RGB 216 120 45	RGB 215 75 39	RGB 144 31 97
CMYK 5 25 73 0	CMYK 5 37 100 0	CMYK 12 62 96 1	CMYK 10 85 100 2	CMYK 42 100 35 13
HEX F0C060	HEX EFA81F	HEX D8782D	HEX D74B27	HEX 901F61

PALETTE 010

RGB 243 246 216
CMYK 4 0 18 0
HEX F3F6D8

RGB 204 204 124
CMYK 22 11 64 0
HEX CCCC7C

RGB 163 74 36
CMYK 25 79 100 18
HEX A34A24

RGB 238 39 59
CMYK 0 97 80 0
HEX EE273B

RGB 115 86 54
CMYK 44 58 82 33
HEX 735636

PALETTE 011

RGB 83 71 76
CMYK 62 64 54 38
HEX 53474C

RGB 166 158 142
CMYK 37 33 43 1
HEX A69E8E

RGB 130 131 114
CMYK 50 40 55 9
HEX 828372

RGB 97 106 101
CMYK 62 47 54 20
HEX 616A65

RGB 75 81 84
CMYK 69 57 54 33
HEX 4B5154

PALETTE 012

RGB 70 109 112
CMYK 75 44 49 17
HEX 466D70

RGB 125 181 185
CMYK 52 14 26 0
HEX 7DB5B9

RGB 242 218 177
CMYK 5 13 33 0
HEX F2DAB1

RGB 199 106 40
CMYK 18 67 100 5
HEX C76A28

RGB 120 74 30
CMYK 37 67 100 35
HEX 784A1E

PALETTE 013

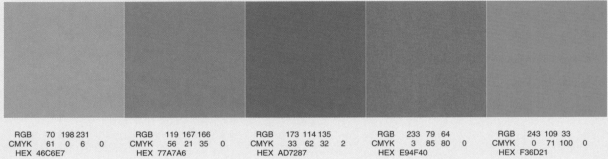

RGB 70 198 231
CMYK 61 0 6 0
HEX 46C6E7

RGB 119 167 166
CMYK 56 21 35 0
HEX 77A7A6

RGB 173 114 135
CMYK 33 62 32 2
HEX AD7287

RGB 233 79 64
CMYK 3 85 80 0
HEX E94F40

RGB 243 109 33
CMYK 0 71 100 0
HEX F36D21

PALETTE 014

RGB 48 48 38
CMYK 66 60 72 64
HEX 303026

RGB 203 49 39
CMYK 14 95 100 4
HEX CB3127

RGB 84 160 130
CMYK 69 18 59 2
HEX 54A082

RGB 231 221 154
CMYK 10 8 47 0
HEX E7DD9A

RGB 48 48 38
CMYK 66 60 72 64
HEX 303026

PALETTE 015

RGB 229 71 69
CMYK 4 87 75 0
HEX E54745

RGB 235 134 90
CMYK 4 58 69 0
HEX EB865A

RGB 235 213 157
CMYK 8 13 44 0
HEX EBD59D

RGB 55 58 74
CMYK 78 70 49 42
HEX 373A4A

RGB 40 43 42
CMYK 72 63 64 66
HEX 282B2A

PALETTE 016

RGB 81 80 78	RGB 241 163 97	RGB 223 94 82	RGB 195 58 69	RGB 87 43 59
CMYK 64 57 58 35	CMYK 3 41 69 0	CMYK 8 78 69 0	CMYK 17 91 73 5	CMYK 51 82 54 48
HEX 51504E	HEX F1A361	HEX DF5E52	HEX C33A45	HEX 572B3B

PALETTE 017

RGB 224 224 159	RGB 240 240 192	RGB 240 216 168	RGB 218 178 138	RGB 19 31 26
CMYK 13 4 46 0	CMYK 6 1 30 0	CMYK 5 13 38 0	CMYK 15 30 48 0	CMYK 77 61 69 77
HEX E0E09F	HEX F0F0C0	HEX F0D8A8	HEX DAB28A	HEX 131F1A

PALETTE 018

RGB 121 18 20	RGB 173 31 45	RGB 214 30 65	RGB 220 161 53	RGB 144 102 40
CMYK 30 100 100 41	CMYK 22 100 89 14	CMYK 10 100 75 2	CMYK 13 38 93 0	CMYK 36 56 100 21
HEX 791214	HEX AD1F2D	HEX D61E41	HEX DCA135	HEX 906628

PALETTE 019

RGB 63 54 42	RGB 230 71 37	RGB 249 158 28	RGB 250 221 0	RGB 253 244 152
CMYK 59 61 73 58	CMYK 4 87 100 0	CMYK 0 44 100 0	CMYK 4 8 100 0	CMYK 2 0 51 0
HEX 3F362A	HEX E64725	HEX F99E1C	HEX FADD00	HEX FDF498

PALETTE 020

RGB 84 152 196	RGB 94 188 103	RGB 240 197 74	RGB 217 55 119	RGB 76 74 123
CMYK 67 29 9 0	CMYK 65 0 80 0	CMYK 6 21 83 0	CMYK 11 93 27 0	CMYK 81 78 26 10
HEX 5498C4	HEX 5EBC67	HEX F0C54A	HEX D93777	HEX 4C4A7B

PALETTE 021

RGB 39 42 100	RGB 212 165 55	RGB 208 41 39	RGB 236 61 36	RGB 114 199 240
CMYK 100 97 30 20	CMYK 18 34 93 0	CMYK 12 98 100 3	CMYK 1 91 100 0	CMYK 50 4 0 0
HEX 272A64	HEX D4A537	HEX D02927	HEX EC3D24	HEX 72C7F0

PALETTE 022

RGB	2 46 46	RGB	10 94 66	RGB	240 216 120	RGB	167 30 34	RGB	27 12 12
CMYK	90 59 65 64	CMYK	89 38 81 33	CMYK	7 11 64 0	CMYK	22 100 100 18	CMYK	64 71 66 84
HEX	022E2E	HEX	0A5E42	HEX	F0D878	HEX	A71E22	HEX	1B0C0C

PALETTE 023

RGB	243 168 109	RGB	211 150 121	RGB	184 140 135	RGB	153 127 135	RGB	117 114 122
CMYK	2 39 62 0	CMYK	16 45 53 0	CMYK	28 47 41 1	CMYK	42 50 37 4	CMYK	56 50 42 11
HEX	F3A86D	HEX	D39679	HEX	B88C87	HEX	997F87	HEX	75727A

PALETTE 024

RGB	0 0 0	RGB	124 181 145	RGB	255 242 175	RGB	242 103 34	RGB	210 34 39
CMYK	0 0 0 100	CMYK	54 11 53 0	CMYK	1 2 38 0	CMYK	0 74 100 0	CMYK	11 100 100 2
HEX	000000	HEX	7CB591	HEX	FFF2AF	HEX	F26722	HEX	D22227

PALETTE 025

RGB 79 23 22	RGB 196 33 38	RGB 239 87 35	RGB 227 126 37	RGB 245 211 133
CMYK 40 87 80 63	CMYK 16 100 100 6	CMYK 0 82 100 0	CMYK 7 60 100 0	CMYK 4 15 56 0
HEX 4F1716	HEX C42126	HEX EF5723	HEX E37E25	HEX F5D385

PALETTE 026

RGB 244 192 24	RGB 229 136 36	RGB 159 29 33	RGB 242 234 156	RGB 65 42 69
CMYK 4 24 100 0	CMYK 7 54 100 0	CMYK 24 100 100 21	CMYK 6 2 48 0	CMYK 72 84 45 45
HEX F4C018	HEX E58824	HEX 9F1D21	HEX F2EA9C	HEX 412A45

PALETTE 027

RGB 231 222 191	RGB 232 184 143	RGB 235 128 75	RGB 169 57 44	RGB 77 25 16
CMYK 9 9 27 0	CMYK 8 29 45 0	CMYK 4 60 78 0	CMYK 24 89 91 16	CMYK 40 86 85 64
HEX E7DEBF	HEX E8B88F	HEX EB804B	HEX A9392C	HEX 4D1910

PALETTE 028

RGB 72 72 48
CMYK 61 53 79 47
HEX 484830

RGB 120 121 73
CMYK 51 40 81 18
HEX 787949

RGB 144 167 143
CMYK 47 23 47 1
HEX 90A78F

RGB 79 122 117
CMYK 72 38 51 12
HEX 4F7A75

RGB 36 17 33
CMYK 71 80 56 74
HEX 241121

PALETTE 029

RGB 25 20 15
CMYK 68 67 70 82
HEX 19140F

RGB 98 74 47
CMYK 47 60 82 42
HEX 624A2F

RGB 103 166 168
CMYK 62 20 34 0
HEX 67A6A8

RGB 138 194 196
CMYK 46 8 23 0
HEX 8AC2C4

RGB 169 195 196
CMYK 34 13 20 0
HEX A9C3C4

PALETTE 030

RGB 19 17 31
CMYK 82 77 57 76
HEX 13111F

RGB 44 54 64
CMYK 80 67 54 50
HEX 2C3640

RGB 235 210 181
CMYK 7 16 29 0
HEX EBD2B5

RGB 197 171 136
CMYK 24 31 50 0
HEX C5AB88

RGB 81 72 72
CMYK 62 61 58 40
HEX 514848

PALETTE 031

RGB 34 89 63	RGB 34 64 50	RGB 242 209 110	RGB 242 156 80	RGB 242 156 80
CMYK 84 40 80 36	CMYK 80 50 74 54	CMYK 5 15 68 0	CMYK 2 45 77 0	CMYK 2 45 77 0
HEX 22593F	HEX 224032	HEX F2D16E	HEX F29C50	HEX F29C50

PALETTE 032

RGB 166 121 81	RGB 241 94 34	RGB 139 56 29	RGB 240 73 35	RGB 243 243 243
CMYK 31 51 74 11	CMYK 0 78 100 0	CMYK 29 85 100 30	CMYK 0 87 100 0	CMYK 4 2 2 0
HEX A67951	HEX F15E22	HEX 8B381D	HEX F04923	HEX F3F3F3

PALETTE 033

RGB 241 185 27	RGB 241 164 31	RGB 242 138 46	RGB 140 113 90	RGB 216 74 61
CMYK 5 27 100 0	CMYK 4 40 100 0	CMYK 2 55 93 0	CMYK 41 51 65 16	CMYK 10 86 82 1
HEX F1B91B	HEX F1A41F	HEX F28A2E	HEX 8C715A	HEX D84A3D

PALETTE 034

RGB 165 30 34	RGB 242 225 8	RGB 241 159 31	RGB 239 71 35	RGB 85 15 15
CMYK 23 100 100 18	CMYK 8 4 100 0	CMYK 3 42 100 0	CMYK 0 88 100 0	CMYK 38 95 88 60
HEX A51E22	HEX F2E108	HEX F19F1F	HEX EF4723	HEX 550F0F

PALETTE 035

RGB 237 154 194	RGB 213 36 143	RGB 139 191 64	RGB 241 171 37	RGB 241 131 33
CMYK 2 49 0 0	CMYK 11 96 0 0	CMYK 51 4 100 0	CMYK 4 36 97 0	CMYK 2 59 100 0
HEX ED9AC2	HEX D5248F	HEX 8BBF40	HEX F1AB25	HEX F18321

PALETTE 036

RGB 72 166 78	RGB 79 116 53	RGB 127 166 63	RGB 165 191 107	RGB 205 217 160
CMYK 74 10 95 1	CMYK 71 34 100 21	CMYK 56 17 100 2	CMYK 39 10 74 0	CMYK 21 5 45 0
HEX 48A64E	HEX 4F7435	HEX 7FA63F	HEX A5BF6B	HEX CDD9A0

On the CD

Open the CD attached to the inside cover of this book and browse to the "Textures" directory. Within that folder you will find a collection of retro-style textures available as high resolution JPEG files that can be used to add texture and dimension to your retro designs.

TEXTURES

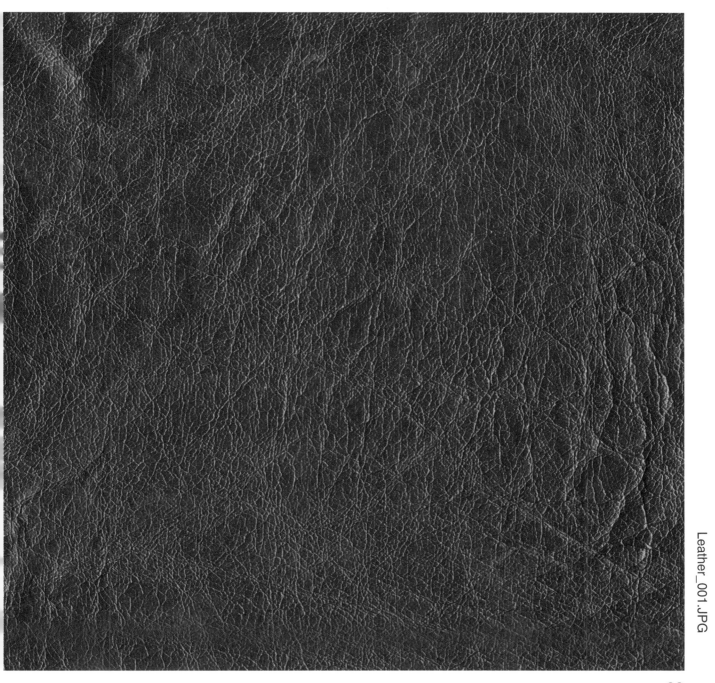

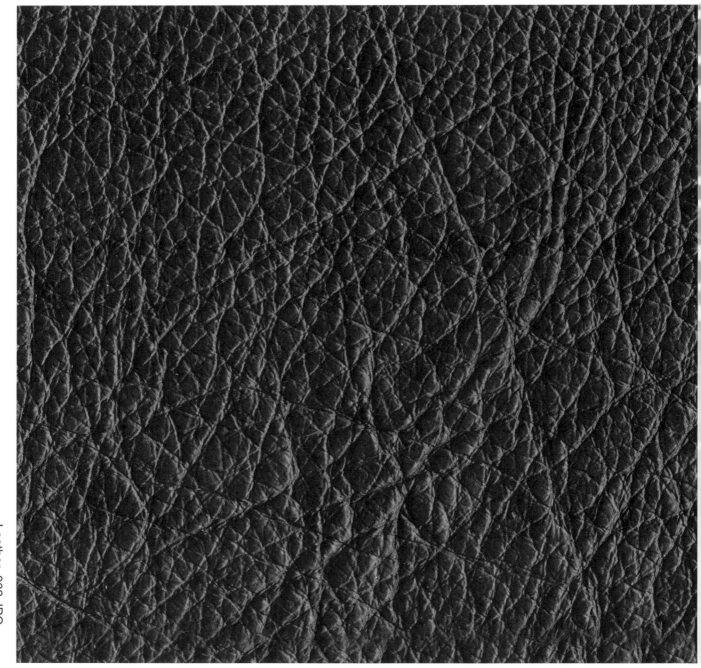

84

88

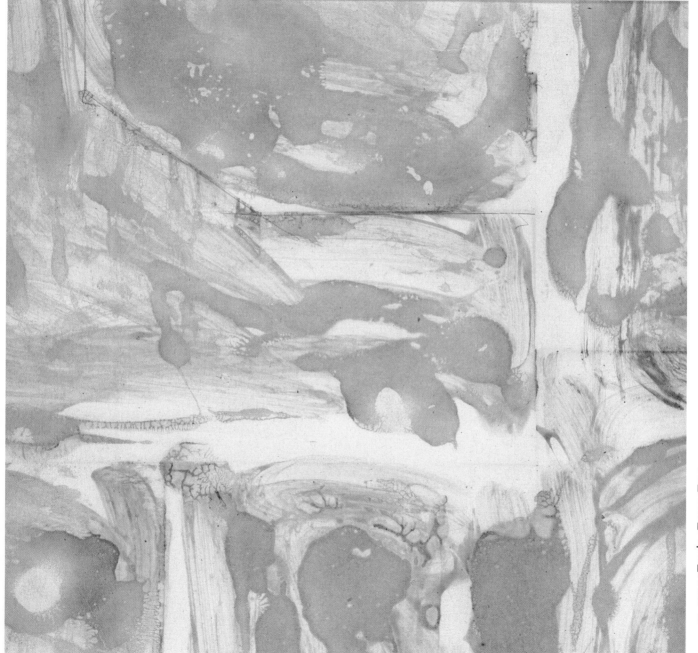

On the CD

Open the CD attached to the inside cover of this book and browse to the "Textured Patterns" directory. Within that folder you will find a collection of retro-style patterned textures available as high resolution JPEG files that can be used to add texture and dimension to your retro designs.

TEXTURED PATTERNS

110

On the CD

Open the CD attached to the inside cover of this book and browse to the "Graphics" directory. Within that folder you will find several vector SVG files that can be imported into your favorite vector editing software and used in your retro-inspired designs.

VECTOR GRAPHICS

Halftones_01.SVG

118

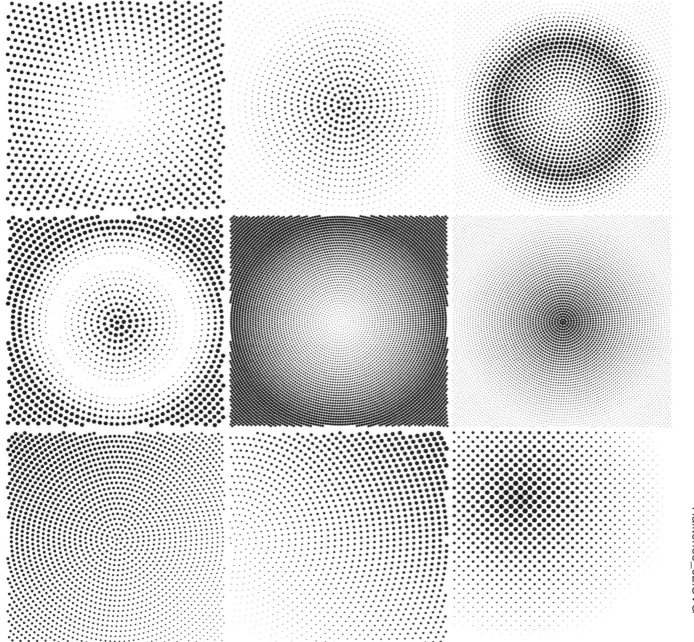

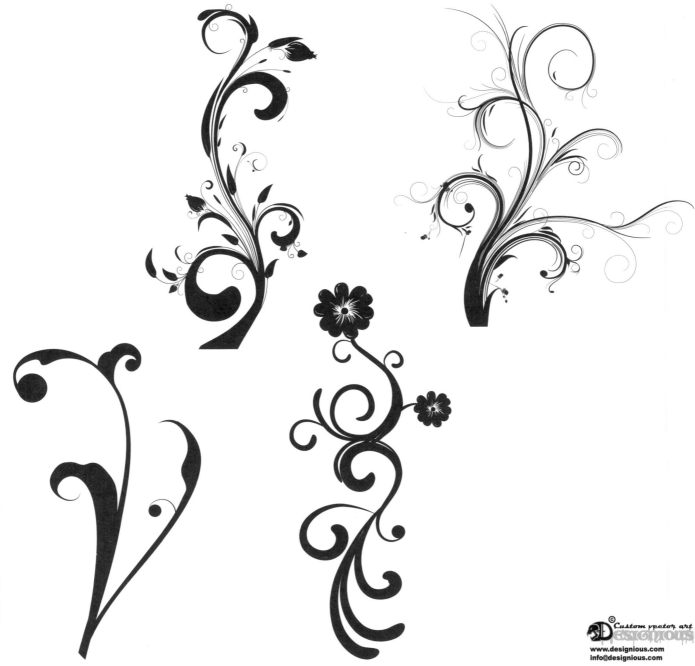

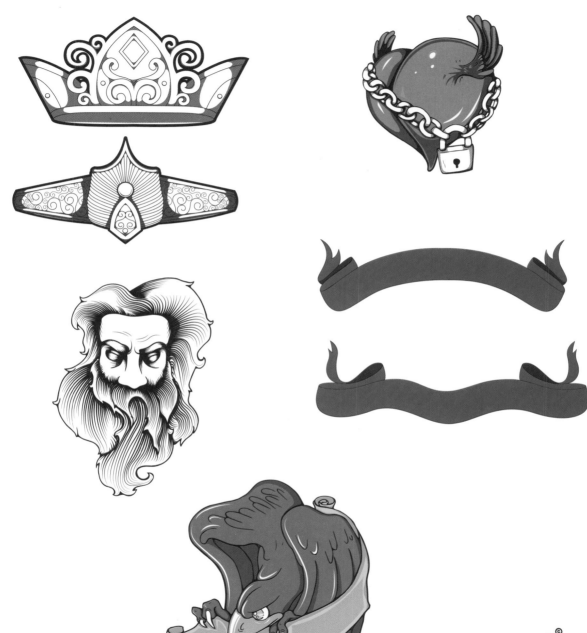

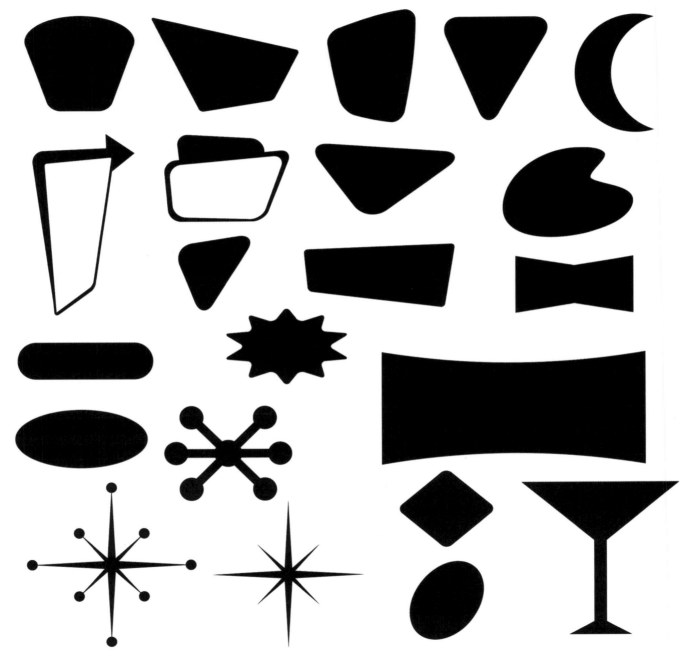

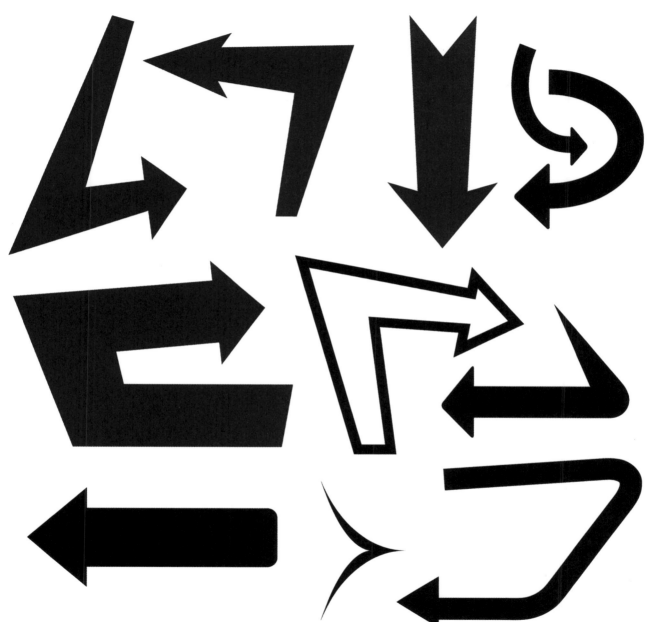

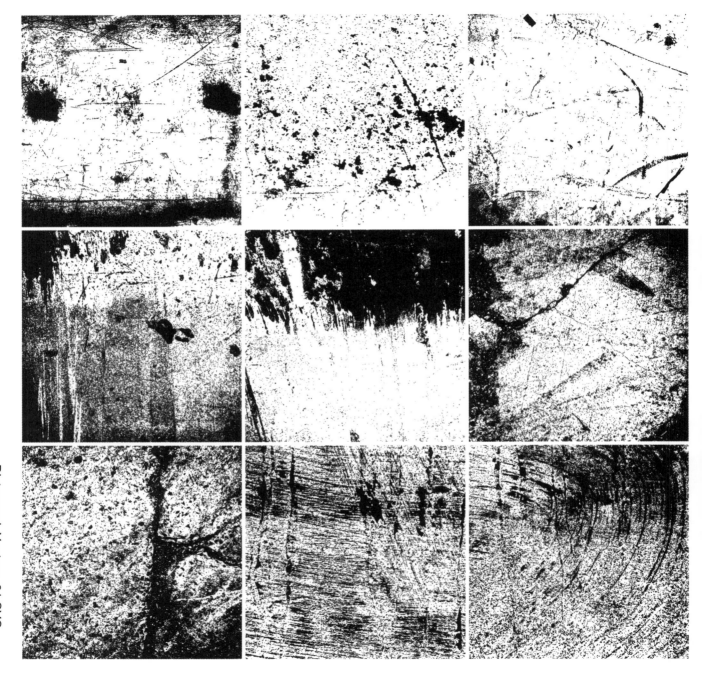

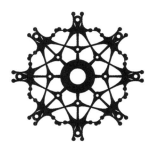

On the CD

Open the CD attached to the inside cover of this book and browse to the "Brushes" directory. Within that folder you will find a collection of retro-inspired brushes that are compatible with either Adobe Illustrator or Photoshop.

ILLUSTRATOR & PHOTOSHOP BRUSHES

10 ARROWHEAD BRUSHES

This Illustrator Brush Library contains a variety of 10 Illustrator brushes that are perfect for creating retro lines with arrowheads. Brushes from this set can be easily applied to any path or shape (including paths with round or sharp corners), in any color.

SAMPLES

10 MISCELENEOUS BORDERS

This Illustrator Brush Library contains a set of 10 Illustrator brushes that are perfect for creating borders around your designs. Many brushes in this set were meant to aid in the reproduction of retro signs from the mid 20th Century but other brushes in this set will also enable you to create beautiful borders around your designs.

SAMPLES

105 RETRO TECH SHAPE BRUSHES

This Illustrator Brush Library contains a set of 105 Illustrator brushes that are perfect for producing retro-style tech shapes. Brushes from this library can be applied to any line or shape and work really well when layered on top of other objects.

105_Retro_Tech_Shape_Brushes.AI

105 RETRO TECH SHAPE RADIALS

This Illustrator Brush Library contains a set of 105 Illustrator brushes that are perfect for creating rays of retro tech shapes. Brushes from this set work very well when applied to circle, oval, or polar grids and will enable you to create stunning designs in a limited amount of time.

ADOBE ILLUSTRATOR COMPATIBLE

INSTALLATION INSTRUCTIONS
**1) Insert your CD. 2) Open Adobe Illustrator.
3) Select Window > Brush Libraries > Other library.
4) Navigate to the brush library on your CD or hard drive, select it, and click Open. 5) The brush library will now appear as a new palette. 6) Consult your manual for more information on loading and using brush libraries.**

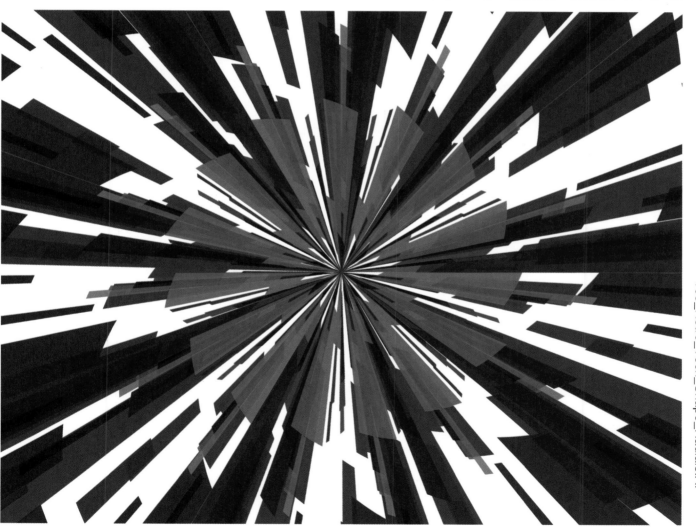

105_Retro_Tech_Shape_Radials.AI

11 HIGH RES DISTRESS BRUSHES

This Photoshop Brush Library contains a set of 11 Photoshop brushes that are perfect for roughing up or distressing your designs to give your retro graphics and older and aged look. Select brushes from this set and use them to take chunks out of your designs by applying them to layer masks.

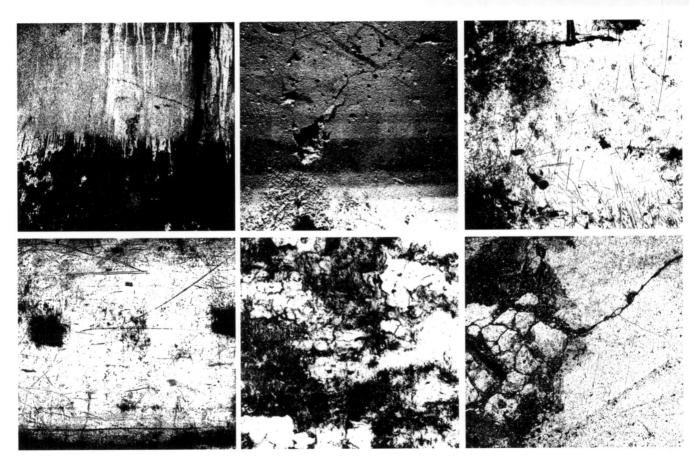

11_High_Res_Distress_Brushes. ABR

160 RETRO CIRCLE BRUSHES

This Illustrator Brush Library contains a massive set of 160 Illustrator brushes that are perfect for creating retro circles. By applying a brush from this library to a circle, you can quickly create an unlimited amount of circles in various colors, shapes and stroke sizes.

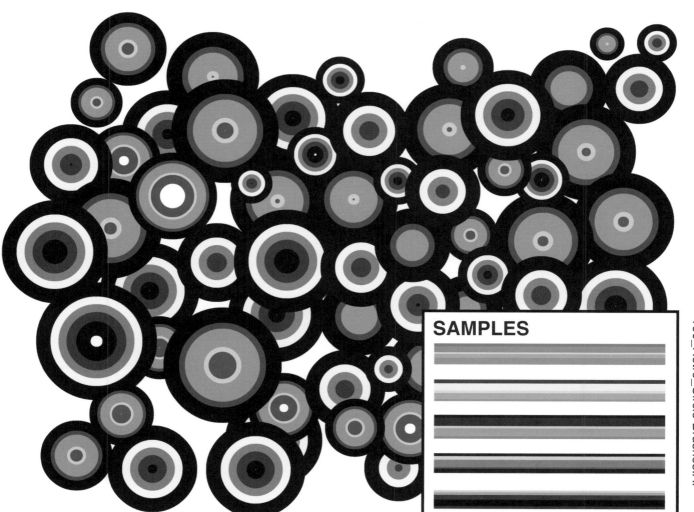

SAMPLES

20 HIGH RES LENS FLARE BRUSHES

This Photoshop Brush Library contains a set of 20 Photoshop brushes that are perfect for quickly creating lens flares. Brushes from this library can be used to add stunning light effects or to create retro cosmic futuristic designs in space.

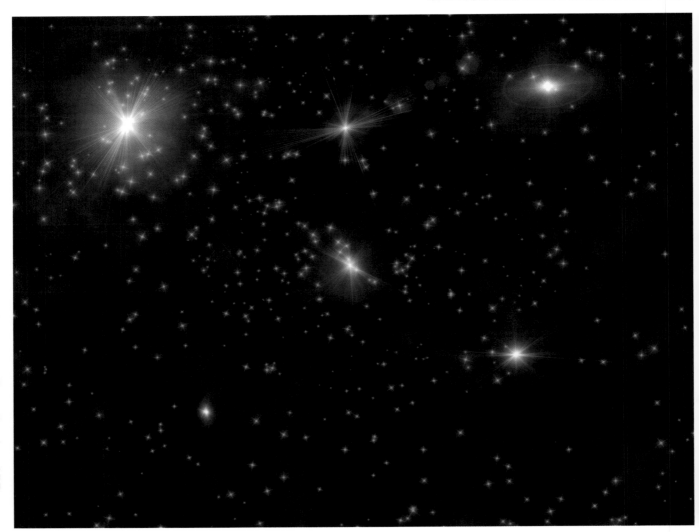

20_High_Res_Lens_Flare_Brushes.ABR

30 RETRO LINE BRUSHES

This Illustrator Brush Library contains a set of 30 Illustrator brushes that are perfect for creating retro-style lines and shapes. Brushes from this library include corner elements and can be applied to any shape. After minimal use, you will find that this set of brushes will become a crucial part of your retro design arsenal.

SAMPLES

30_Retro_Line_Brushes.AI

50 BROKEN LINE BRUSHES

This Illustrator Brush Library contains a set of 50 Illustrator brushes that are perfect for creating a variety of broken line shapes. Brushes from this set include corner objects and work very well when applied to just about any shape including squares, circles, and polar grids.

SAMPLES

50_Broken_Line_Brushes.AI

50 BROKEN LINE RADIALS

This Illustrator Brush Library contains a set of 50 Illustrator brushes that are perfect for creating rays of broken line shapes. Brushes from this set work very well when applied to circle, oval, or polar grids and will enable you to quickly create stunning backgrounds for your designs.

50_Broken_Line_Radials.AI

The Retro Gallery

This book contains an enormous amount of
resources that you can use to spice up your retro
designs but what good are resources unless you
know how to best apply them? The Gallery section
of this book contains several retro-inspired works
by professional designers that can help guide you
when you attempt to put the resources found in
this book to use.

GALLERY

Christopher Hanley, Carrihan Creative Group

Christopher Hanley, Carrihan Creative Group

Christopher Hanley, Carrihan Creative Group

Christopher Hanley, Carrihan Creative Group

POCKETBABY
C L O T H I E R

Christopher Hanley, Carrihan Creative Group

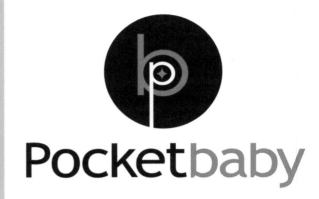

Pocketbaby

Christopher Hanley, Carrihan Creative Group

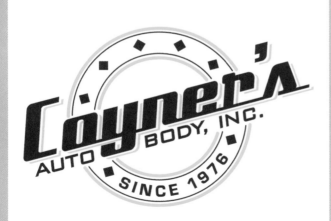

Jeff Fisher, Logo Motives

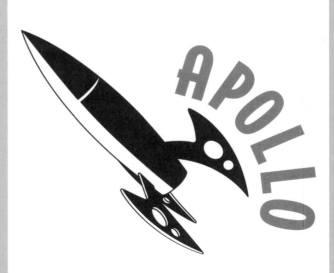

Luke McKean

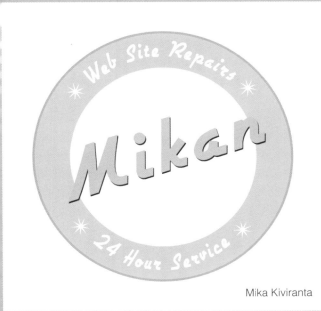

Mika Kiviranta

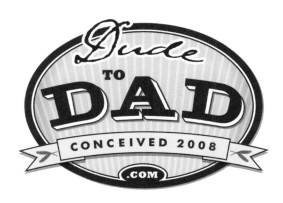

Eric Raasch, Mind Flame Design & Marketing

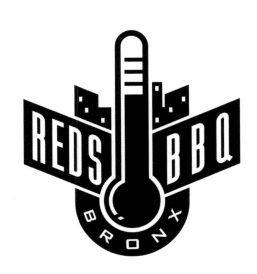

Masood Bukhari

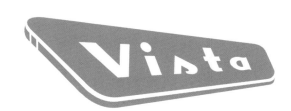

Masood Bukhari

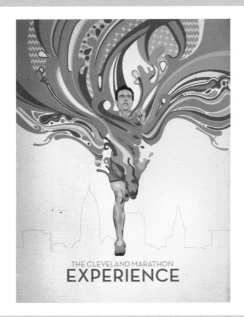

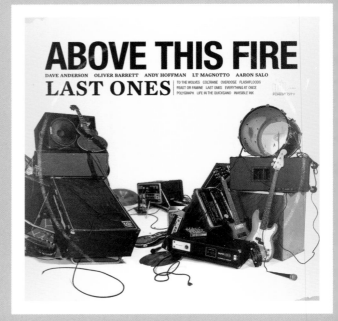

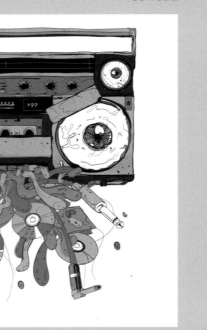

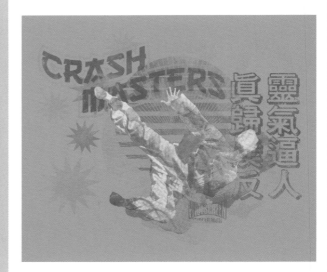

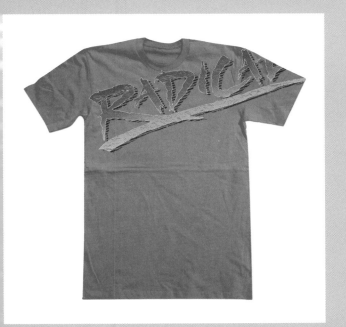

Go Media

Go Media

Springer Design, Inc

Springer Design, Inc

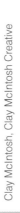

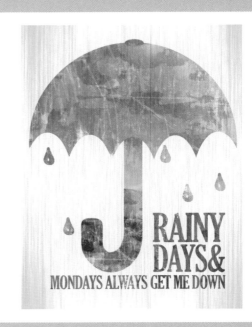

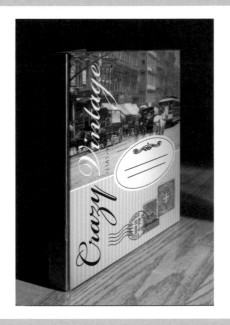

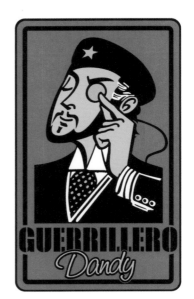

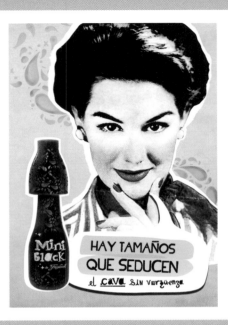

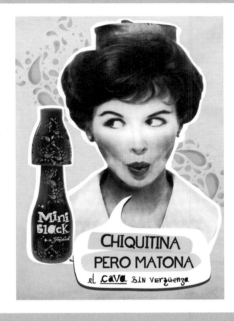

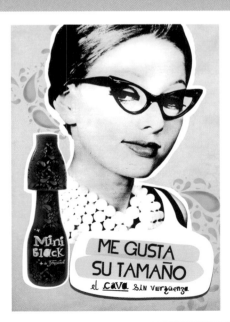

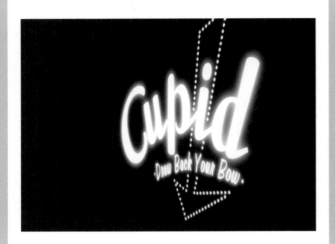

Masood Bukhari

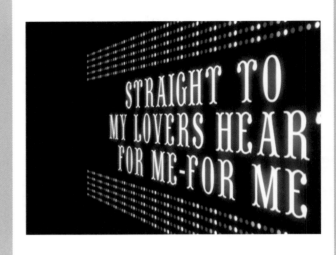

Masood Bukhari

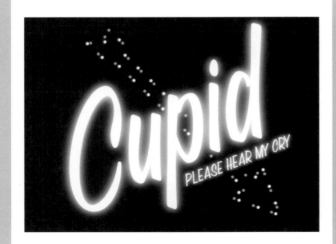

Masood Bukhari

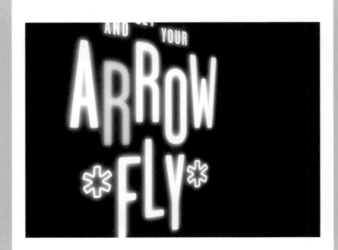

Masood Bukhari

Masood Bukhari

Masood Bukhari

Masood Bukhari

Masood Bukhari

On the CD

Open the CD attached to the inside cover of this
book and browse to the "Resources" directory.
Within that folder you will find an HTML file that
contains links to several retro-inspired tutorials,
articles, and resources that can be used to aide
you in your attempts to create
retro-inspired artwork.

RESOURCES

TUTORIALS, FREE DOWNLOADS & INSPIRATION ONLINE

When creating beautiful pieces of retro artwork it is important to use high quality resources such as patterns, graphics, textures, and fonts. Good retro designs however are more than just the sum of their parts. Good retro design is also about knowing what to do with these resources once you have identified the elements that you would like to use to create your art. This section is a collection of free retro inspiration, resources, and tutorials from around the web. To access these links, insert your CD into your computer's tray and open the html file that accompanies this book in the Resources directory.

TUTORIALS

PHOTOSHOP

Design a Retro Futurism Space Scene
Learn how to design a retro-futuristic space scene using a variety of lighting effects and photo manipulations.
PSDFAN.COM

Yet Another Colorization Tutorial
Colorize a black and white photo.
WORTH1000.COM

Create a Wicked-Worn Vintage Pop Art Design
Learn how to design a simple but nice vintage pop art piece with a little wear and tear.
PSD.TUTSPLUS.COM

Creating A Retro Grunge Poster
Create a retro/grunge style poster.
ONLINE-PHOTOSHOPTUTORIALS.COM

Give Your Photos a Retro Comic Book Effect
Create a visually appealing comic book style effect.
PHOTOSHOPROADMAP.COM

Pin-up Effect
Use a mixture of filters and blending modes to create a classic 1950's style pin up poster.
PLANETPHOTOSHOP.COM

Gigposter Design: The New Sex
Create a retro-style gig poster for a band.
GOMEDIAZINE.COM

Create a Vintage Polaroid Effect
Reproduce a vintage Polaroid effect.
MYINKBLOG.COM

Craft a Vintage Fifties Letter
Learn how to make an envelope look old and grungy.
PSD.TUTSPLUS.COM

Make it Worn
A great tutorial outlining the process of creating a worn looking website.
SUBDUED.NET

A Retro Wallpaper/Poster Step by Step Photoshop Tutorial
A step by step tutorial showing how to create a retro line wallpaper.
UBLTUTS.CO.UK

Mix Cool Retro Curves into Your Photographs
Add a retro feel to your design by adding some cool retro curves.
PSD.TUTSPLUS.COM

How to Design a Rockin' 80's Party Poster
Learn how to design a poster for an 80's-Themed party.
PSD.TUTSPLUS.COM

Design a Rocket-Powered Retro-Futuristic Digital Illustration Screencast
A video tutorial detailing the steps to create an experimental retro futuristic illustration.
PSD.TUTSPLUS.COM

How to Quickly Create a Stylish Retro Text Effect Screencast

Design a cool retro text effect using the perspective tool in Photoshop.
PSD.TUTSPLUS.COM

How to Create a Super Retro Style Game Controller

Learn how to create a retro-style game controller in Photoshop.
PSD.TUTSPLUS.COM

Create a 60's Psychedelic Style Concert Poster

Learn how to create a psychedelic 1960's style concert poster.
PSD.TUTSPLUS.COM

Super Retro Game Cartridge Design

Create a 3 dimensional retro game cartridge.
PSD.TUTSPLUS.COM

Retro Geometric Vectors in Space with Illustrator and Photoshop

Mix Illustrator and Photoshop to create cool geometric vectors in space.
ABDUZEEDO.COM

The O Series

Create an abstract retro design using a series of overlapping circles and gradients.
SIGNALNOISE.COM

ILLUSTRATOR

Create an Angry-Clean Bar of Vector Soap

Create a retro bar of soap in the "Fight Club" style.
VECTOR.TUTSPLUS.COM

How to Create a Colorful Retro Style TV

Use gradients and layers to create a retro-style television.
VECTOR.TUTSPLUS.COM

HOW TO MAKE A FOOLPROOF FLOWERY WALLPAPER PATTERN

Learn how to create seamless repeating patterns of your own using Illustrator.
VECTOR.TUTSPLUS.COM

Design a Vintage Nintendo-style Controller and Cartridge

Create a retro-inspired game controller in Illustrator.
VECTOR.TUTSPLUS.COM

How to Create a Trendy Retro Type Treatment

Create a trendy retro type treatment using gradients, blends, and scatter brushes.
VECTOR.TUTSPLUS.COM

Create a Retro Style Poster with Shapes, Patterns, and Eagles

Create a retro-style poster using shapes and patterns.
VECTOR.TUTSPLUS.COM

DOWNLOADS

PHOTOSHOP RESOURCES

350+ Retro and Vintage Photoshop Brushes

This is a great collection of retro Photoshop brushes from around the web.
DESIGNM.AG

208 Retro Photoshop Patterns

A huge collection of retro patterns and backgrounds for Photoshop.
WELLMEDICATED.COM

ILLUSTRATOR RESOURCES

Free Vector Repeat Patterns

Three very nice vector patterns inspired by the retro style.
PATTERNHEAD.COM

Free Vector Repeat Patterns

Three very nice vector patterns inspired by the retro style.
PATTERNHEAD.COM

Free Vector Repeat Pattern - Retro Style

A seamless vector pattern inspired by the retro style.
PATTERNHEAD.COM

INSPIRATION

40 Beautiful Examples of Vintage and Retro in Web Design

A list of 40 beautifully designed websites in the retro style.
SIXREVISIONS.COM

25 Inspiring Sites that Use Repeat Patterns and Seamless Textures Effectively

A list of 25 websites that use repeating patterns effectively.
PATTERNHEAD.COM

Retro designs in the vehicle industry

A list of older model vehicles and their modern counterparts.
DENISDESIGNS.COM

General Mills Retro Cereal Boxes

A selection of retro cereal boxes.
THEDIELINE.COM

50 Mind-blowing Retro-style Photoshop Illustrations

An incredible round up of retro style Photoshop illustrations.
PSD.TUTSPLUS.COM

Retro and Vintage In Modern Web Design

A very nice article explaining the retro style in web design.
SMASHINGMAGAZINE.COM

Celebration of Vintage and Retro Design

This article celebrates some of the most appealing retro-inspired designs.
SMASHINGMAGAZINE.COM

Textures and Patterns Design Showcase

This article explains some of the best practices when using patterns and textures in your designs.
SMASHINGMAGAZINE.COM

Vintage and Retro Typography Showcase

Be inspired with this excellent showcase of retro typography.
SMASHINGMAGAZINE.COM

Back to the Past: Retro Car Ads Inspiration

An inspiring look at retro automobile advertisements.
DESIGNINTERVIEWS.COM

Retro Logos on Flickr

A huge collection of retro logos from the mid-70's.
FLICKR.COM

1930's Style Travel Posters

A beautiful collection of 1920's – 1930's travel posters.
CONCEPTART.ORG

Vintage Type on Flickr

This fantastic group on Flickr contains thousands of images of vintage type to inspire you.
FLICKR.COM

Retro Science Fiction Inspired Book Covers

Scans of retro science fiction covers.
FLICKR.COM

ACKNOWLEDGEMENTS

I have always enjoyed a challenge. As a designer, I have had the opportunity to work on several large projects. When I was approached by Angela Patchell to write this book I knew that creating the content and layout for a book of this size was going to be one of the biggest projects that I had ever worked on but because of time restraints, I knew that I would have to reach out to others for help. I was both surprised and humbled that so many distinguished designers and agencies would come to my aide by providing their fonts, designs, textures, and stock imagery. That is why I would like to offer my heartfelt thanks and appreciation to the following agencies and individuals that helped to make this book possible.

FONT DESIGNERS & FOUNDRIES

Stuart Sandler
Font Diner
FONTDINER.COM

Tom Plate
PINSTRIPING.EU

David Cohen
SQUIDART.COM

Alan Meeks
ALANMEEKS.COM

Mark Simonson
MARKSIMONSON.COM

Harold Lohner
HAROLDSFONTS.COM

Michael Doret
MICHAELDORET.COM

DESIGN RESOURCES

Marcel Vijfwinkel
CGTEXTURES.COM

Go Media
GOMEDIA.US
Special thanks to Jeff Finley & Adam Wagner

Designious
DESIGNIOUS.COM
Special thanks to Alex Dumitru

GALLERY SUBMISSIONS

Christopher Hanley
Carrihan Creative Group
CARRIHAN.COM

Clay McIntosh
Clay McIntosh Creative
CLAYMCINTOSH.COM

Dara Denney
A Rad Design
TWITTER.COM/
DARALAINEWAINE

Dasha Wagner
DM Graphic Design Collection
DM-DESIGN-COLLECTON.COM

Eric Raasch
Mind Flame Design & Marketing
MINDFLAMEDESIGN.COM

Go Media
GOMEDIA.US

Jeff Fisher
Logo Motives
JFISHERLOGOMOTIVES.COM

Luke McKean
BEHANCE.NET/AWHATNOT

Masood Bukhari
MASOODBUKHARI.COM

Mika Kiviranta
MIKAN.FI

Nicolas "Kaaliss" Cornwall & Julía Solans
KAALISS.COM
JULIASOLANS.COM

Springer Design, Inc
SPRINGERDESIGNINC.COM

Victor M Martinez
Mandarina Design
CREATIVEHUB.COM/USERS/
VICTOR-MARTINEZ/

ABOUT THE AUTHOR

Grant Friedman is a design enthusiast, author and blogger with a wide range of experience in the design industry. His work has been featured in many popular websites and publications. Grant has a degree in Telecommunications from the University of Kentucky with a background in graphic and web design, advertising and communications.

Grant founded Colorburned Creative in 2008 as a means to showcase his designs, offer his thoughts on current design trends, as well as to deliver professional quality design resources to others. Since then, his website has become a popular destination for designers looking for resources, inspiration and information.

As a blogger, designer and writer Grant is in a position to not only follow design trends but to also help expose those trends to others. Grant sees himself not as just a designer but also a student and teacher. Grant hopes that by providing resources and tools to other designers that he can not only help others but also grow as a designer himself.

To learn more about Grant, visit his website at colorburned.com or follow him on Twitter at twitter.com/colorburned.

THE END